Coloring
Ocean Mandalas

30 Hand-Drawn Designs for Mindful Relaxation

Wendy Piersall

Ulysses Press

To my friends, fans and the team at Ulysses Press.
I am eternally grateful for your love and support!
❁❁❁

Published by
Ulysses Press
P.O. Box 3440
Berkeley, CA 94703
www.ulyssespress.com

ISBN: 978-1-61243-546-6

Printed in Canada by Marquis Book Printing

10 9 8 7 6 5 4 3 2 1

Acquisitions editor: Kelly Reed
Managing editor: Claire Chun

Distributed by Publishers Group West

Introduction

When I illustrated my first coloring book for adults, *Coloring Animal Mandalas*, I thought it would be a fun little side project and I would promptly get back to blogging, as I have done since 2006. Then Ulysses Press offered another project, *Coloring Flower Mandalas*, which suddenly turned my little "side project" into the most blissful, rewarding, and fun career opportunity one could possibly imagine. *Coloring Dream Mandalas* rapidly followed, and I am so incredibly grateful to my friends, fans, and the team at Ulysses Press, that this fourth book is dedicated to ALL OF YOU.

As I wrote in the introduction to *Coloring Flower Mandalas*, I get asked almost daily about how to color and what materials are best to use. I've written an extensive and very popular post on my blog about that here: www.WendyPiersall.com/How-to-Color. I have updated the page to cover even more of my favorite art materials and some relaxation tips. I also offer a free geometric mandala coloring book to download, which can be found on that same page. Go grab it and have fun with it!

It never gets old to see your colored pages on Instagram, Facebook, and Twitter. Your creativity and imagination never cease to amaze me! Please tag your photos on Instagram with #wendypiersall or #coloringoceanmandalas so that I can find you, or post them to my Facebook page at www.Facebook.com/WendyPiersallArt. You can also tweet your photos to me @eMom. If you are curious about how I color my own art, I've started a YouTube channel with videos of my process at www.YouTube.com/user/WendyPiersall.

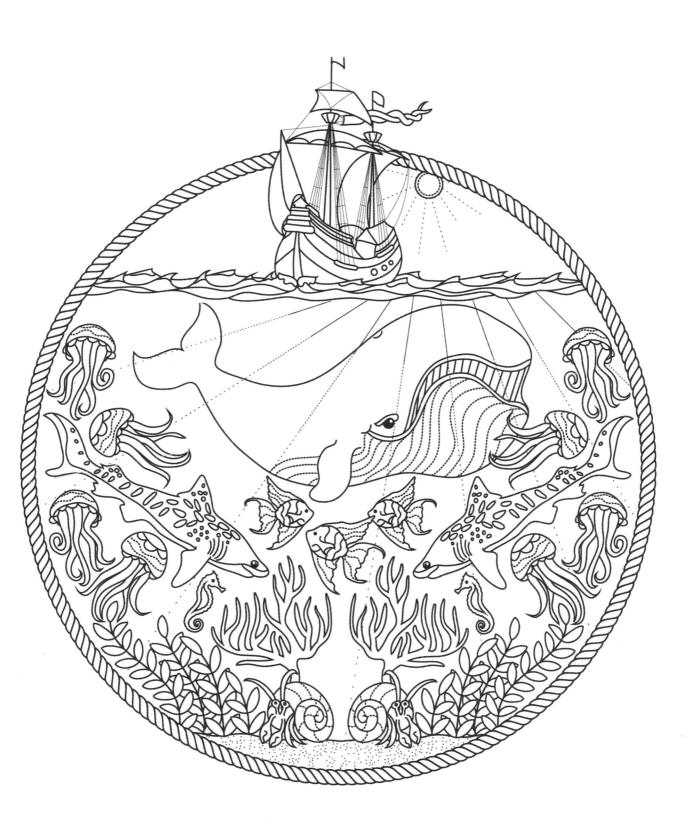

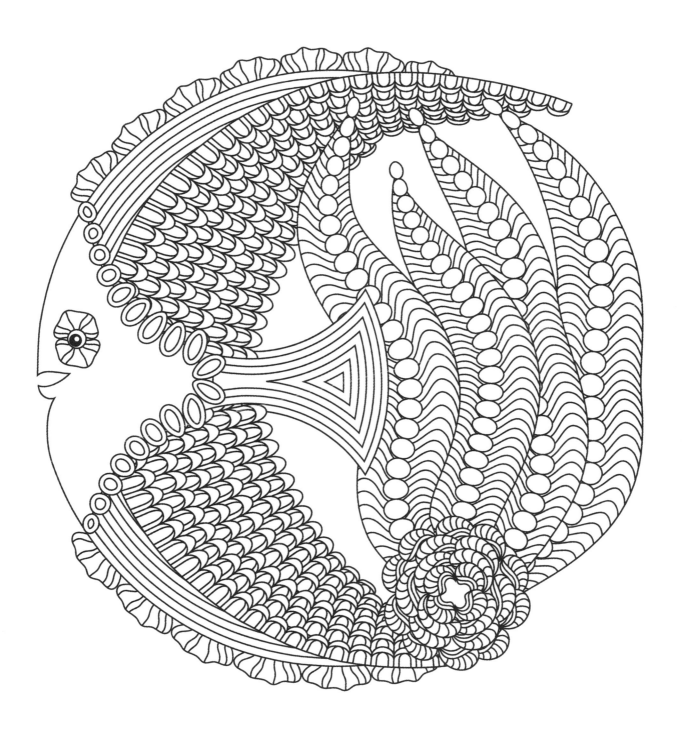

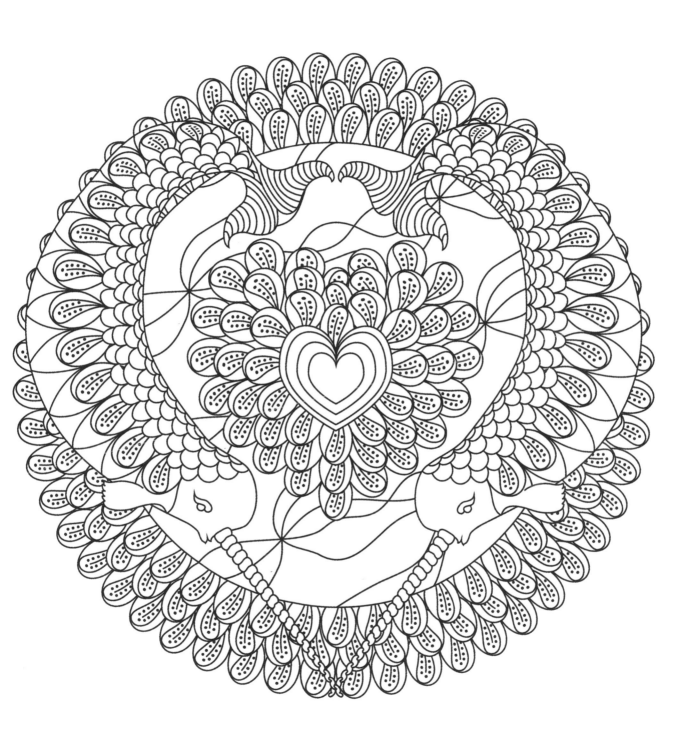

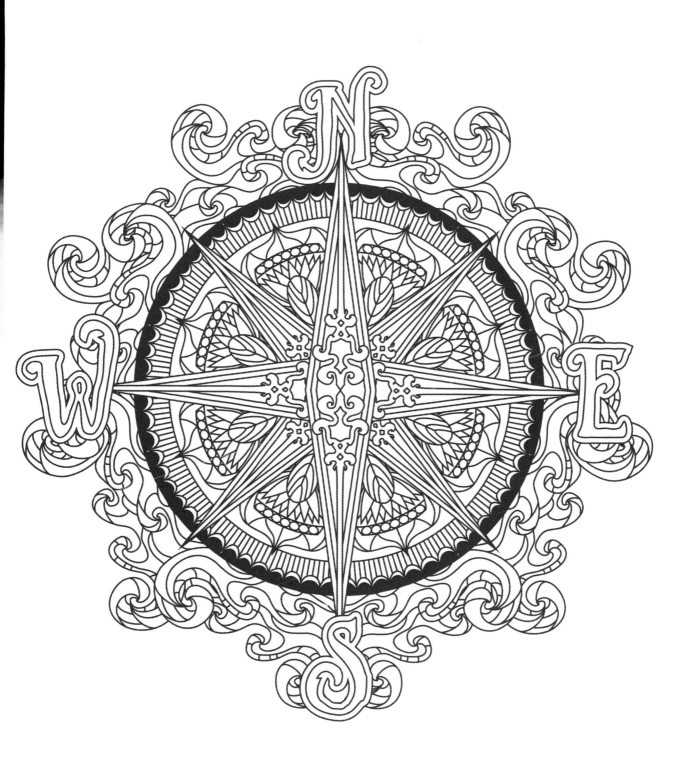

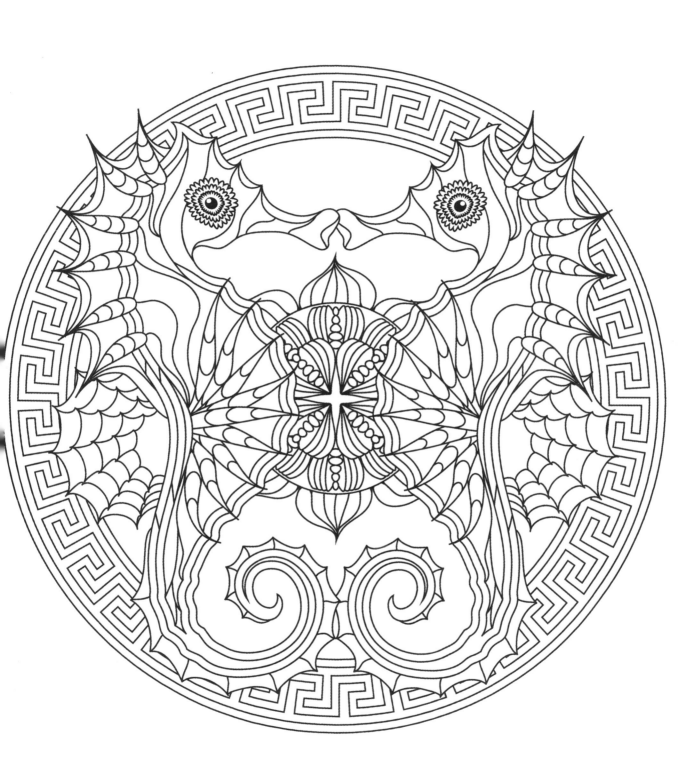

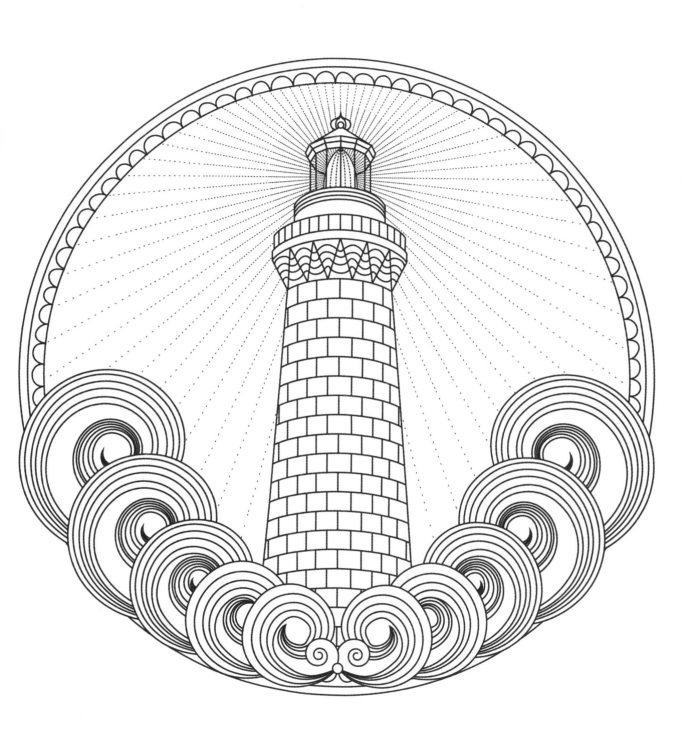

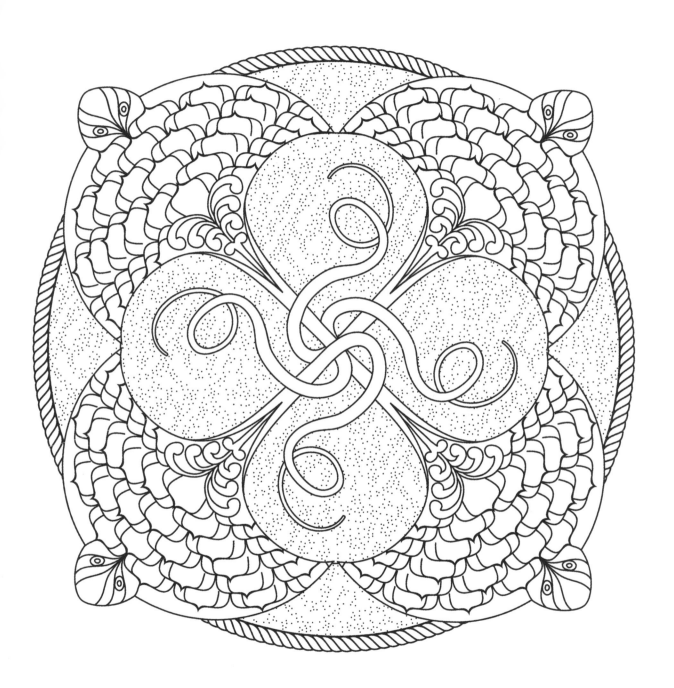

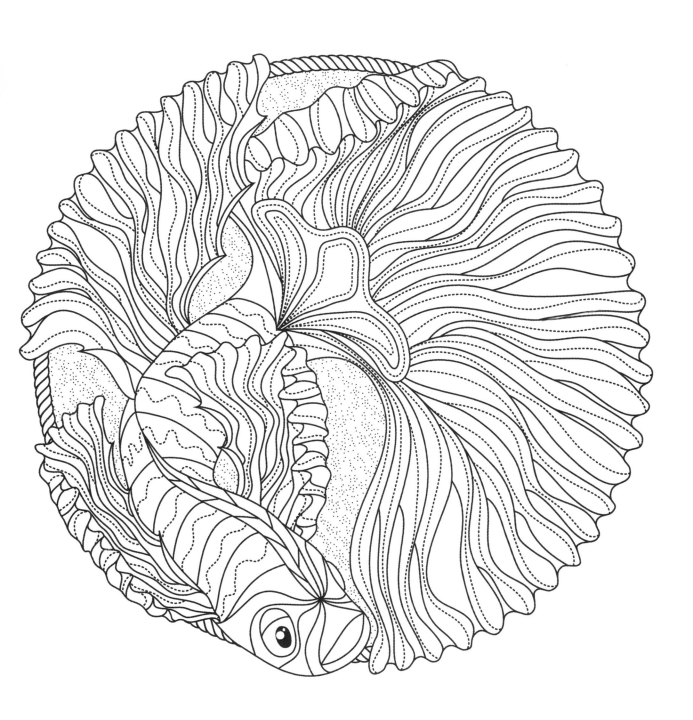

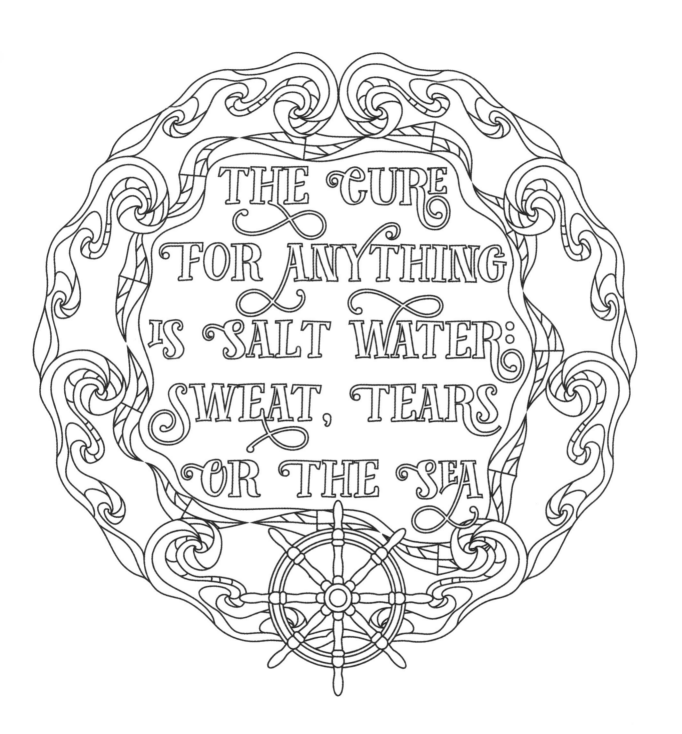

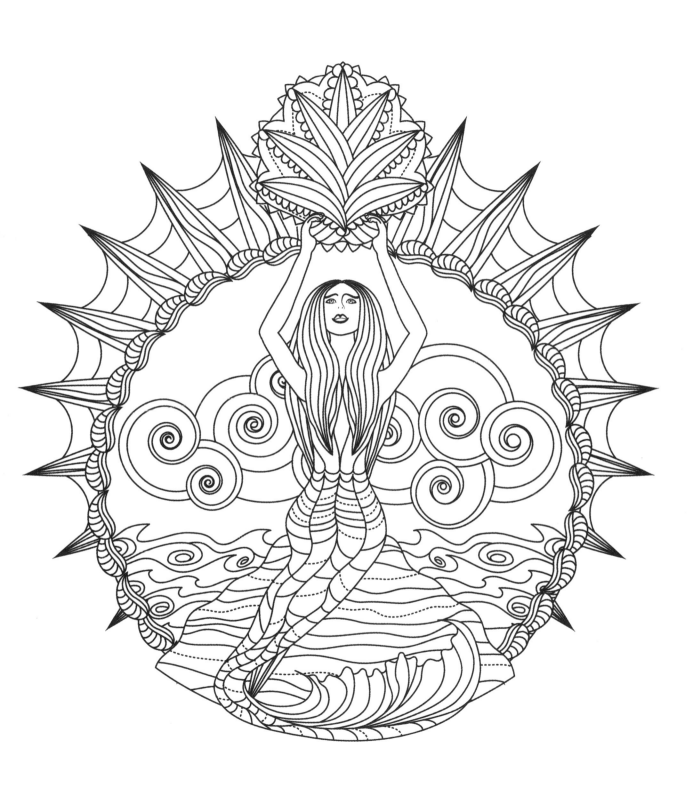

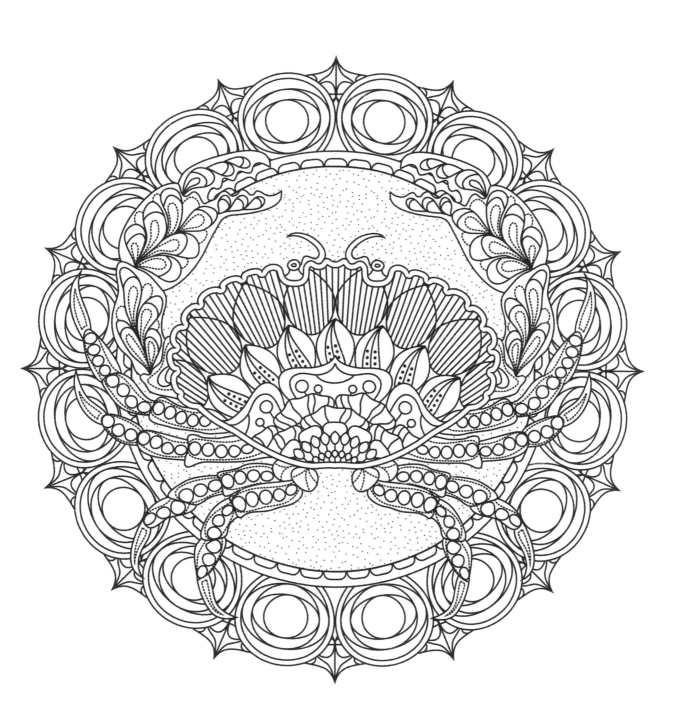

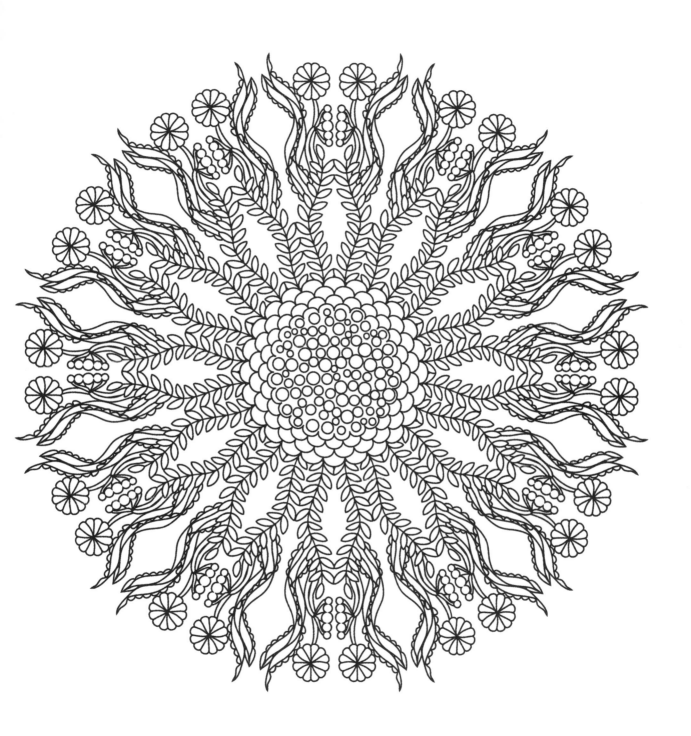

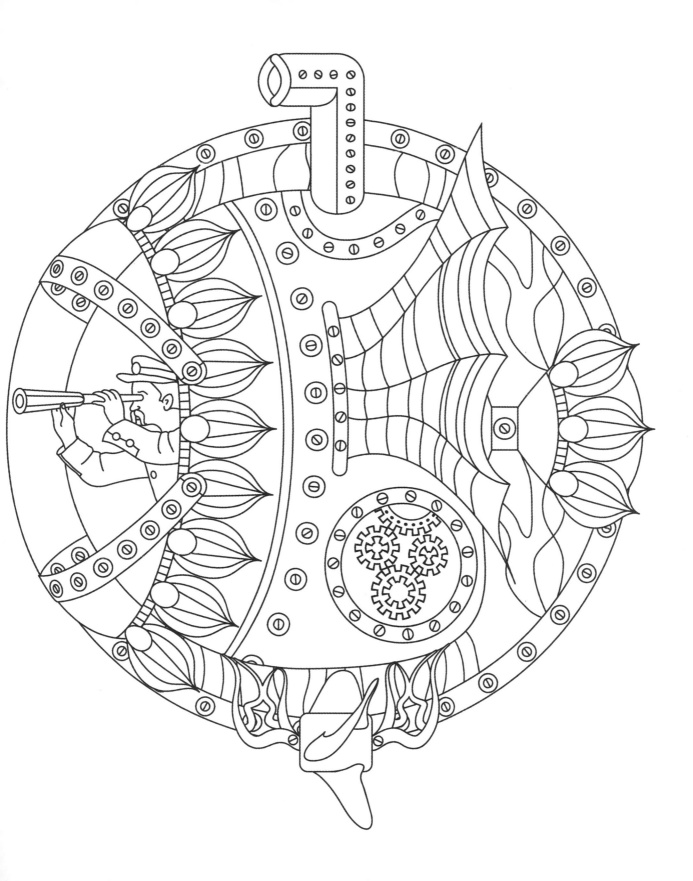

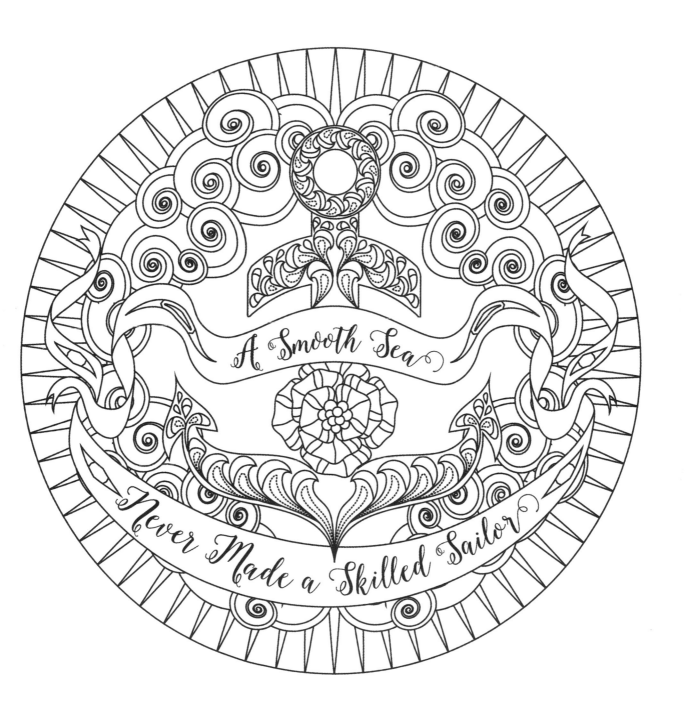

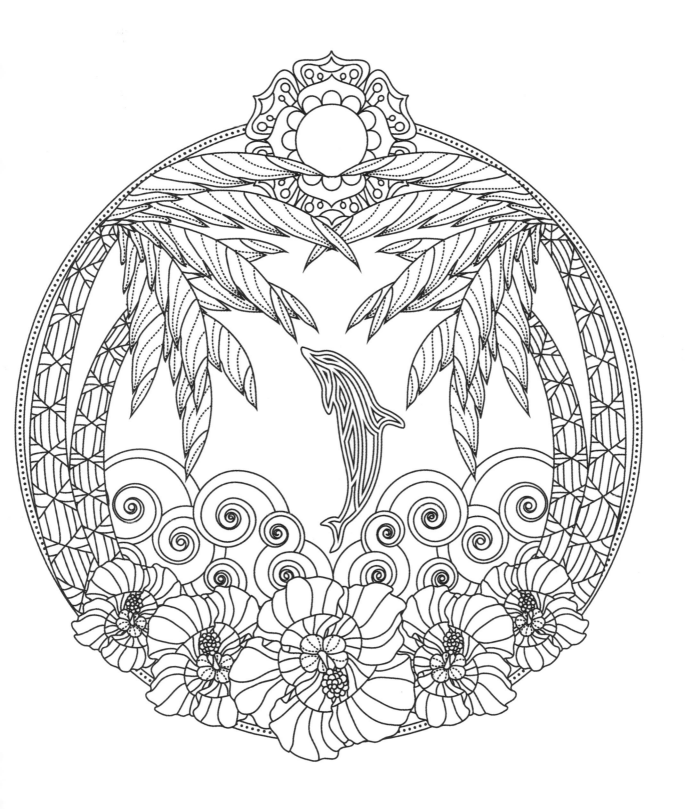

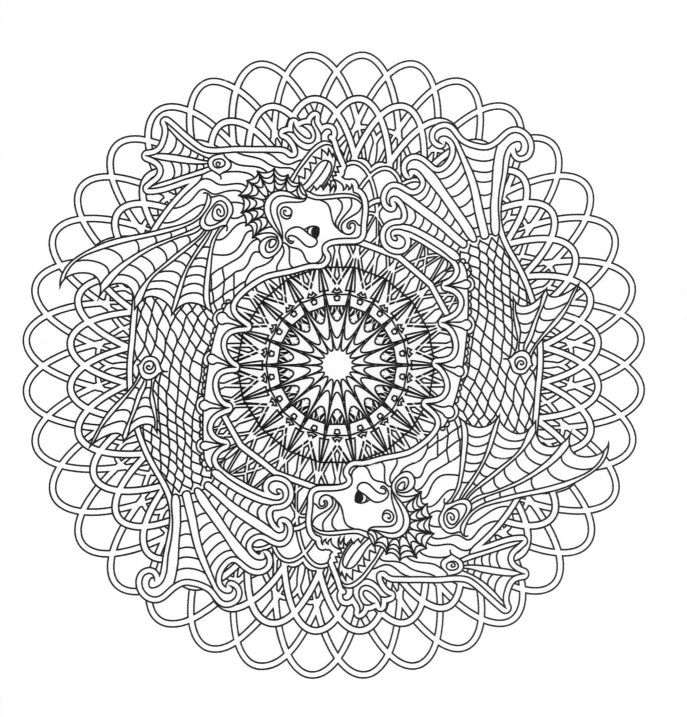

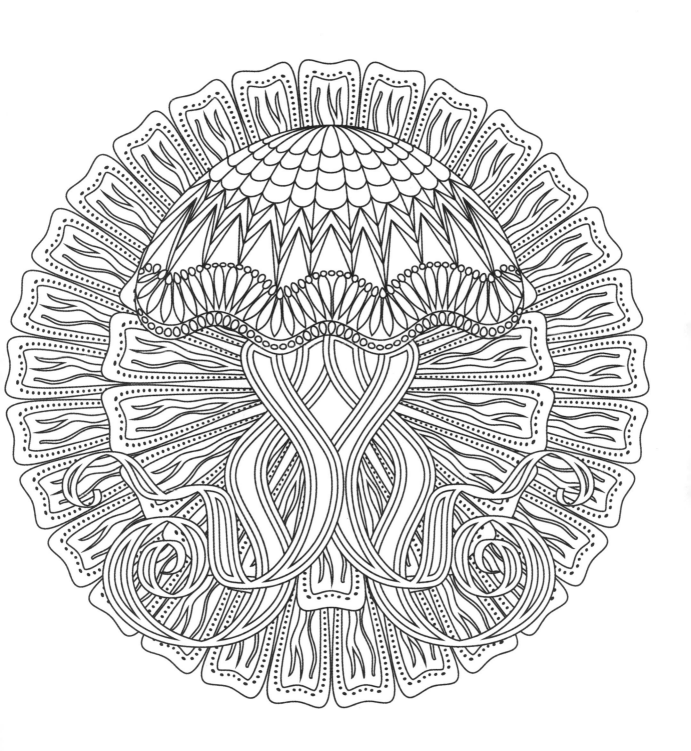

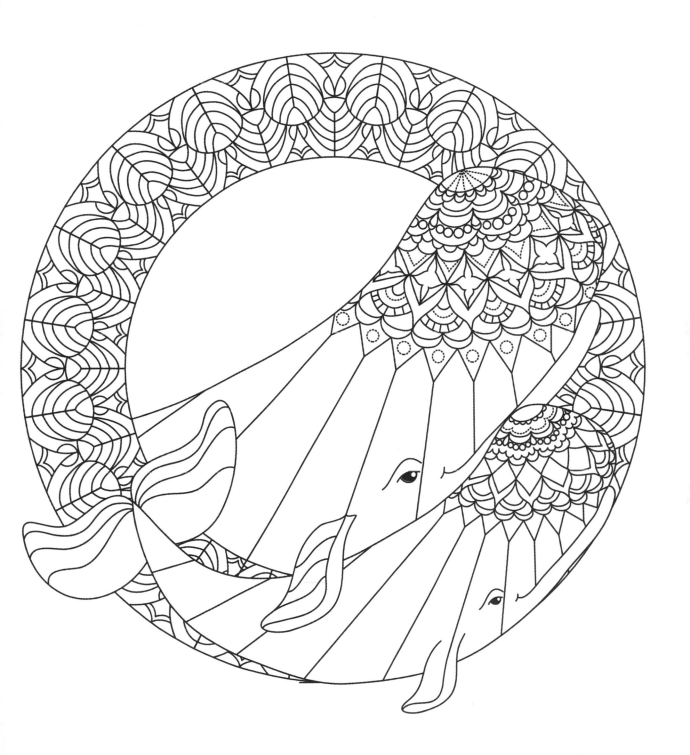

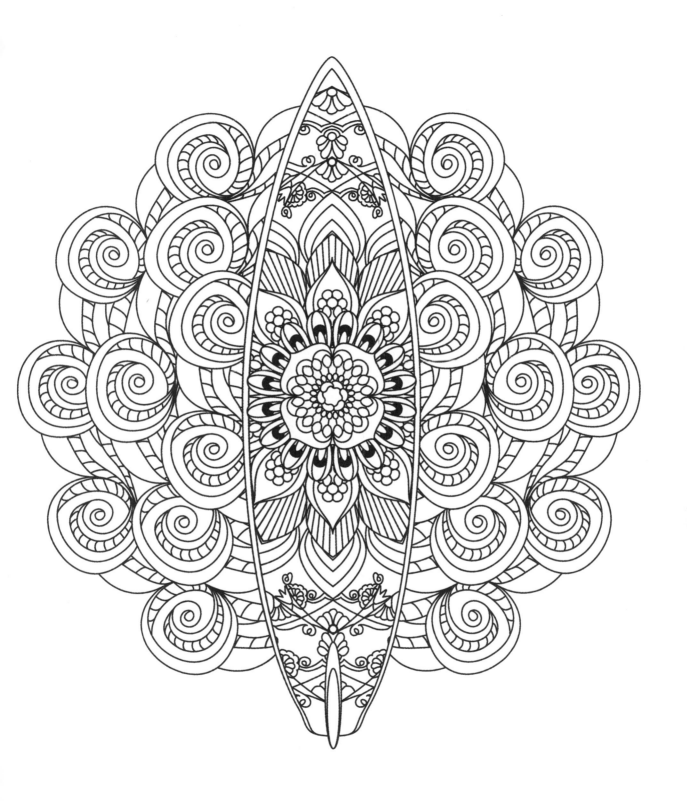

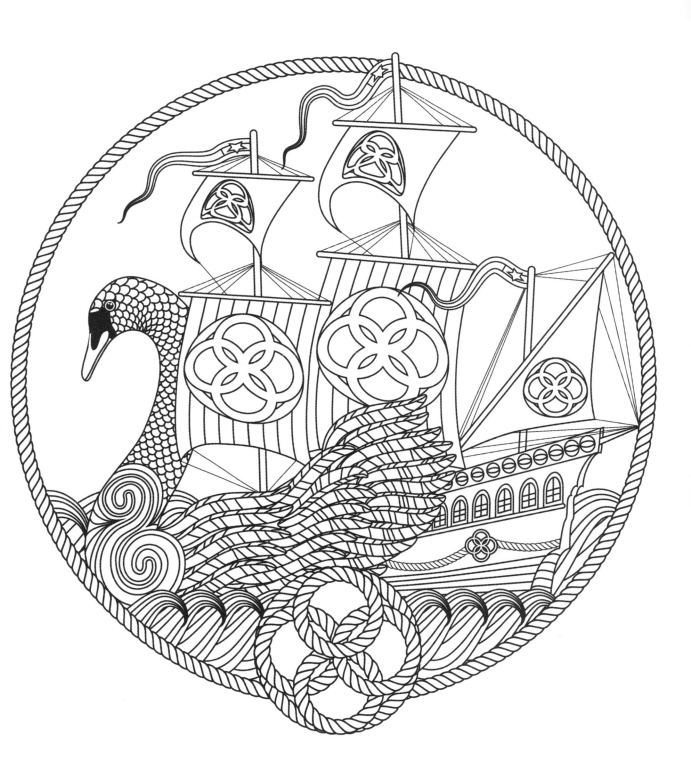

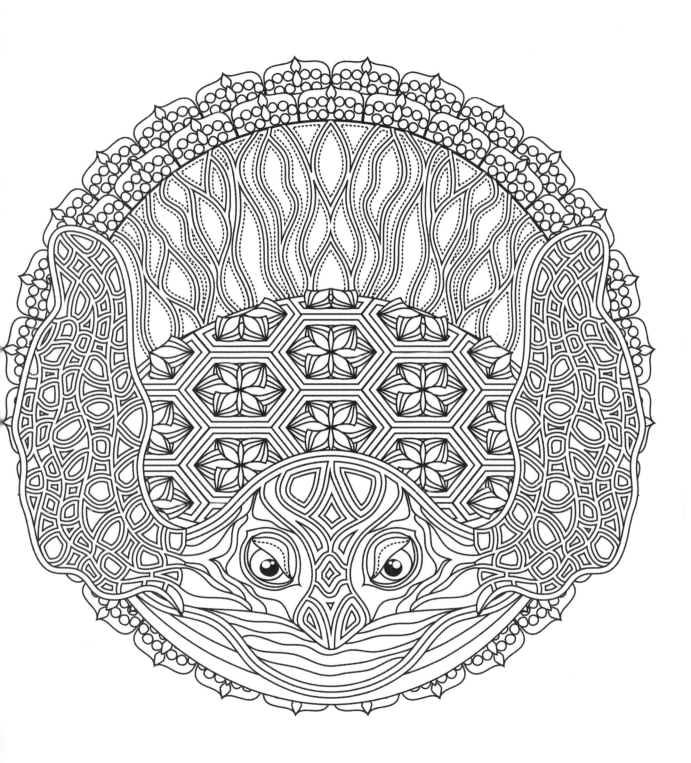

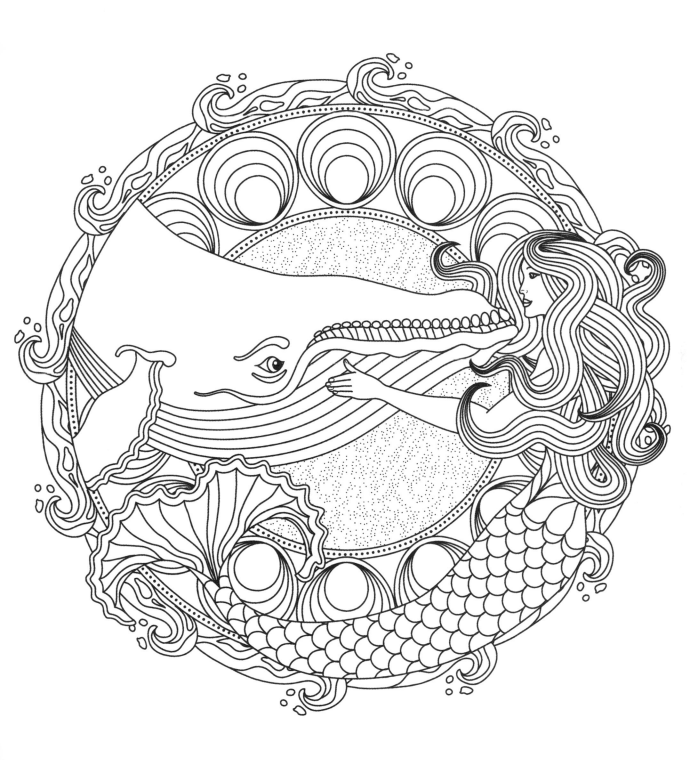

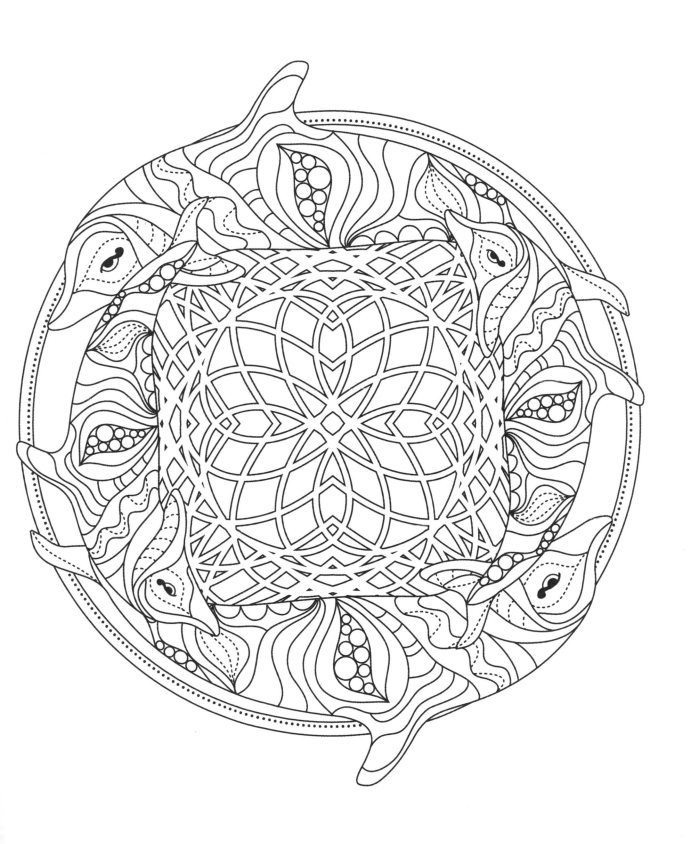

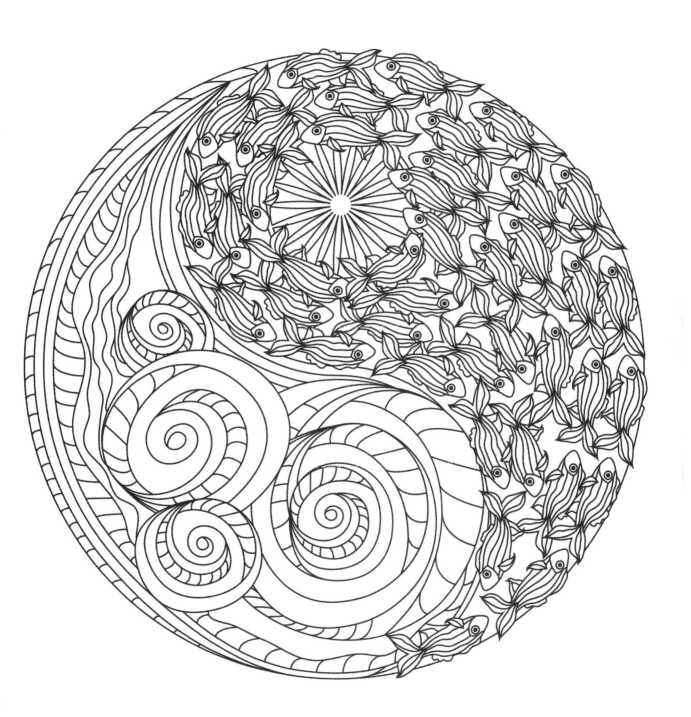

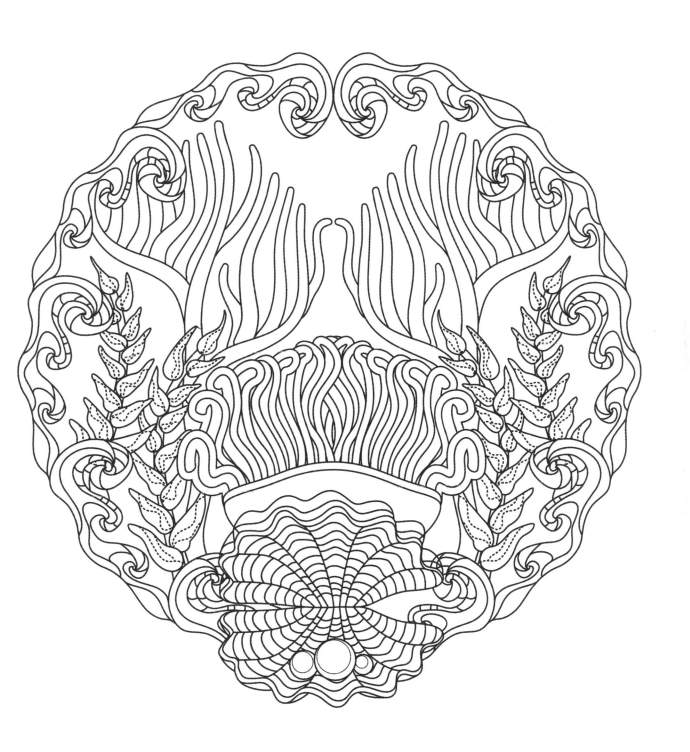

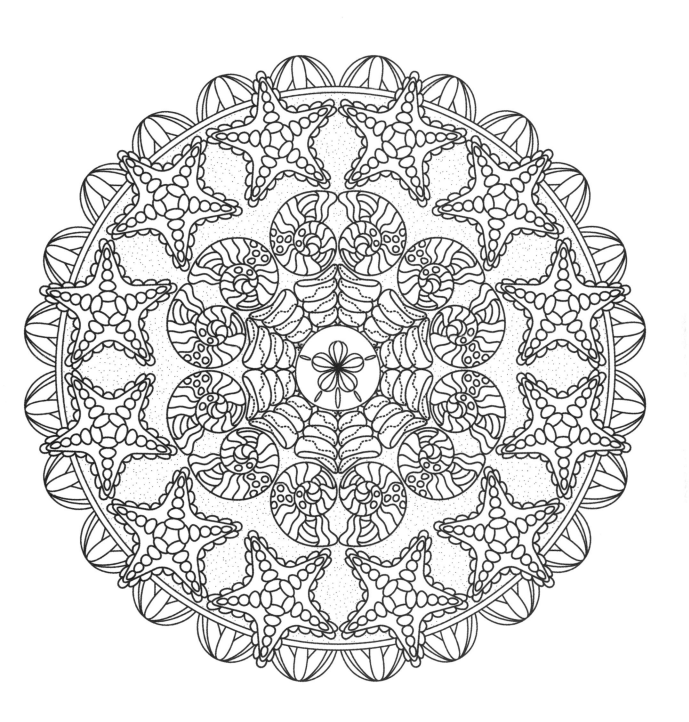

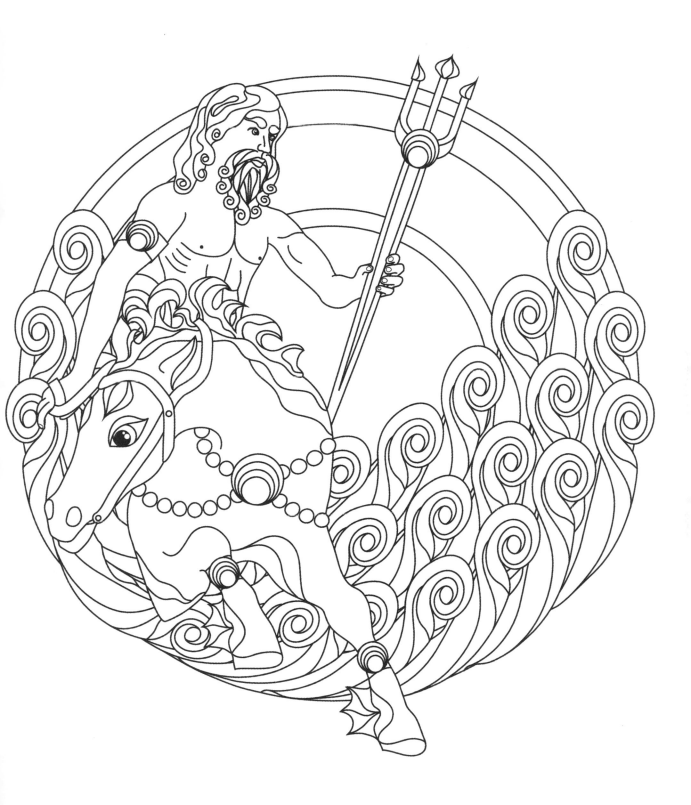

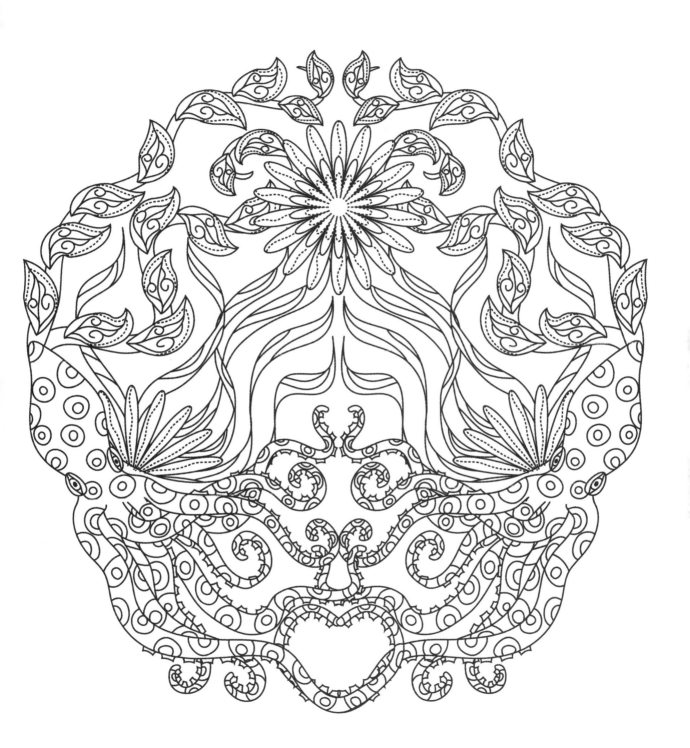

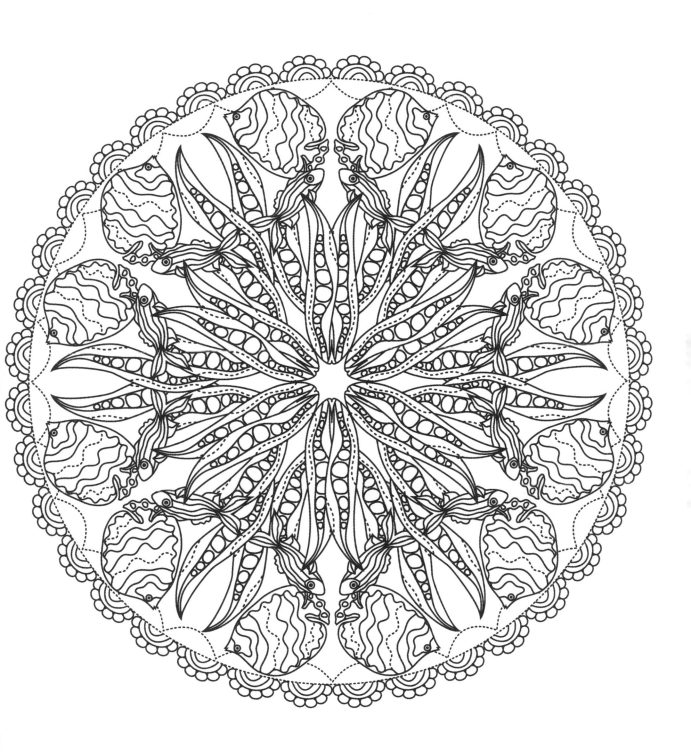